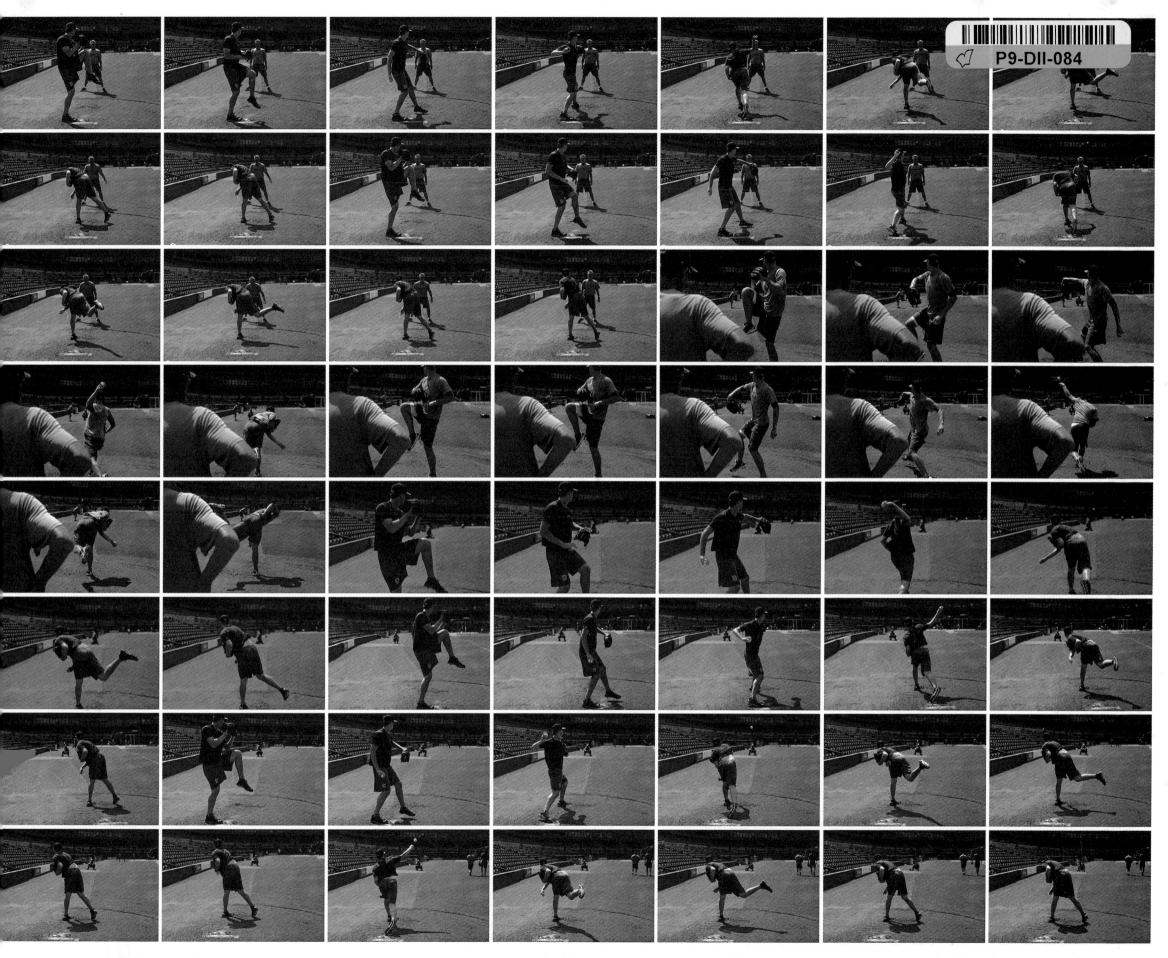

Daylight

EDITED BY SAM STEPHENSON

BULL CITY SUMMER

A SEASON AT THE BALLPARK

D

10 Y E A R
ANNIVERSARY

Cofounders: Taj Forer and Michael Itkoff
Designer: Ursula Damm
Copy editor: Chris Bamberger

Edited by Sam Stephenson

ISBN 978-0-9889831-6-8

Printed in China

Daylight Books
E-mail: info@daylightbooks.org
Web: www.daylightbooks.org

In 2013, a team of artists converged on the
Durham Bulls Athletic Park in Durham, North
Carolina to document the 72-game season.
The results are presented here.

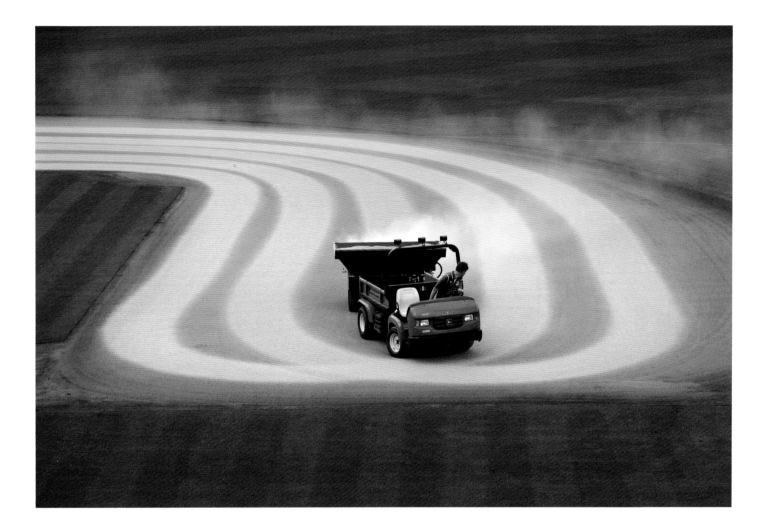

TABLE OF CONTENTS

July 10, 2013.

Charlotte Knights at Durham Bulls. Top of the 6th. No outs. Full count, Odorizzi walks Gallagher, Sanchez reaches on fielder's choice ground ball to pitcher, Gallagher advances to 3rd on Odorizzi throwing error, Gallagher scores on McDade sacrifice fly:

Bulls 2-1.

NATIONAL PRESENT TIME

Adam Sobsey

Unless you are a baseball adept, or familiar with Durham, North Carolina, your relationship to the words *Durham Bulls* may be an inverted one. Perhaps your mind flips the words to *Bull Durham*, the 1988 movie about life and love in the minor leagues. Kevin Costner stars as journeyman catcher Crash Davis (there was a real Durham Bull by that name, long ago). He is sent to Durham to tutor the young, talented, and wild Nuke LaLoosh (Tim Robbins), a flamethrowing pitcher who is never sure where his pitches will go. Nuke spends the summer canoodling with Annie Savoy (Susan Sarandon), an aging baseball groupie who gives him tutelage in a different kind of baseball, before he is called up to "The Show," the major leagues. That clears the way for Crash and Annie to become the battery mates, as baseball argot puts it, they were destined to be. It is a mellow, even melancholy consummation, a sadder-but-wiser ending to an antic, shaggy, often profane baseball tale of getting all the way to the major leagues, to the end of the summer, to the end of a career.

Bull Durham gets a lot right, and real minor leaguers approve of it. My multiyear polling of ballplayers in clubhouses shows it to be the truest baseball movie: players identify with the bus-ride scenes (the minors are still known colloquially as the bus leagues), with Crash's lament of the "dying quail" difference between hitting .250 and .300 (the difference that'll get you to the majors), and with the lecture Crash gives Nuke on how to fob off sports clichés on reporters.

But *Bull Durham* does omit a crucial detail, one that the casual viewer will probably overlook. To most people, professional baseball divides into two absolute milieus: the majors and the minors. In fact, the minors comprise multiple levels, from short-season rookie ball up through the three discrete tiers of Single A, then Double A, and—just below the majors—Triple A. (It's a long way up.) When *Bull Durham* was made, the real Durham Bulls were a Single-A team, and the movie's depiction of the game is of that level: sloppy, clumsy, jejune. Most players at Single A level lack the tools to make it to the majors (they're out of baseball long before they get close), which is what makes Nuke LaLoosh so extraordinary. When he is called up to the majors, he leapfrogs right over Double A and Triple A. This is so rare an occurrence that it rings a little false—most players climb the ladder rung by rung—but the problem of authenticity is solved by simple irrelevance in this case: it doesn't matter to the story which circle of minor league purgatory *Bull Durham* occupies. We only need to know what Annie tells Nuke, who, after his call-up, promises her that he'll come back for her. "Honey," she says, with tender condescension, "When somebody leaves Durham, they don't come back."

It's on that line that *Bull Durham* and the real Durham Bulls part ways.

The modern Durham Bulls have upgraded both of their settings. In 1994, they moved out of historic Durham Athletic Park, a charmingly shabby World War II relic (*Bull Durham* was shot there), and into Durham Bulls Athletic Park, about a mile away from the old park and twice the size. The DBAP, as it's known, was designed by Populous, formerly known as HOK Sport, the architecture firm that started the vogue for retro-modern urban ballparks with Camden Yards in Baltimore in the early 1990s.

In 1998, the Bulls themselves received a promotion from the High-A Carolina League to the Triple-A International League. They ended their longtime affiliation with the Atlanta Braves and signed on as the top farm team of a brand-new franchise, the Tampa Bay Rays.

The promotion to Triple A means that when players leave Durham, they do come back—all the time, and by design. Up through Double A, the minors are mostly about advancement, progress, and hope. Not so in Triple A, which is primarily a holding pen for fringe big leaguers, most of whom have already played in the majors, some of them for years, and now find themselves on an up-and-down escalator between the fine wine of The Show and the small beer of Triple A. (It's a long way down.) There are a few hot prospects on their inevitable rise to long, starry careers, who don't stay long, and there is a small portion of more slowly developing players, who need two or even three seasons at Triple A before earning their way up and out; but the rosters are mostly unstable shadow squads of doppelgangers and reservists, rehabbers and reclamation projects.

They are called up and sent back down, sometimes the very next day, often three or four times in a season. They are "designated for assignment," a ballplayer's three least favorite words, which can result in anything from the ego-damaging formality of losing his claim on a big league opportunity, to getting his outright release from the organization. Those who have opt-out clauses written into their contracts might request their own release so they can sign on with another team, which might give them a better chance at the big leagues. A few players are traded; a handful retire, either because their bodies break down or because they just can't perform anymore. All have been beset by injury, misfortune, fatal flaws, and regression—that is, by the years. The Bulls' opening day roster in 2010 was older than the Tampa Bay Rays'. Triple A is mostly a battle of youth versus age—that is, of mortality.

Despite the appearance of motion in the form of constant change, that change results mostly in an overall flatness—the shrug of .500 baseball—as good players are promoted, bad ones demoted or replaced with better. It's hard to be great in Triple A and hard to be terrible, too. Consequently, although the essence of all sport is winning and losing, it doesn't much matter to most Triple-A ballplayers (or to their parent club) whether their team wins, except as a vestigial matter of morale. They wear the Durham Bulls uniform, but they do not work for the Bulls. They are paid property of the Tampa Bay Rays, and every baseball player would rather play for the worst team in the majors than the best team in Triple A. That's why it is sometimes said that the difference between Triple A and all the other levels of baseball is that no one wants to be in Triple A.

That isn't entirely true. Plenty of ballplayers do want to be here. It beats all the levels below it, of course, and it's certainly better than not playing baseball at all. It even has its own fulfillments, quite apart from the tantalizing potential reward of a trip to the major leagues. Despite its two-way relationship with other levels, and despite its protectorate status, it is its own vivid, exciting, stand-alone world, totally unlike any other in baseball, yet in its essence the most lifelike. Former Bulls catcher Stephen Vogt once told me that Triple A is "the weirdest level," and perhaps

Alex Harris

Frank Hunter
Kate Joyce
Elizabeth Matheson
Leah Sobsey
Alec Soth
Hank Willis Thomas
Hiroshi Watanabe

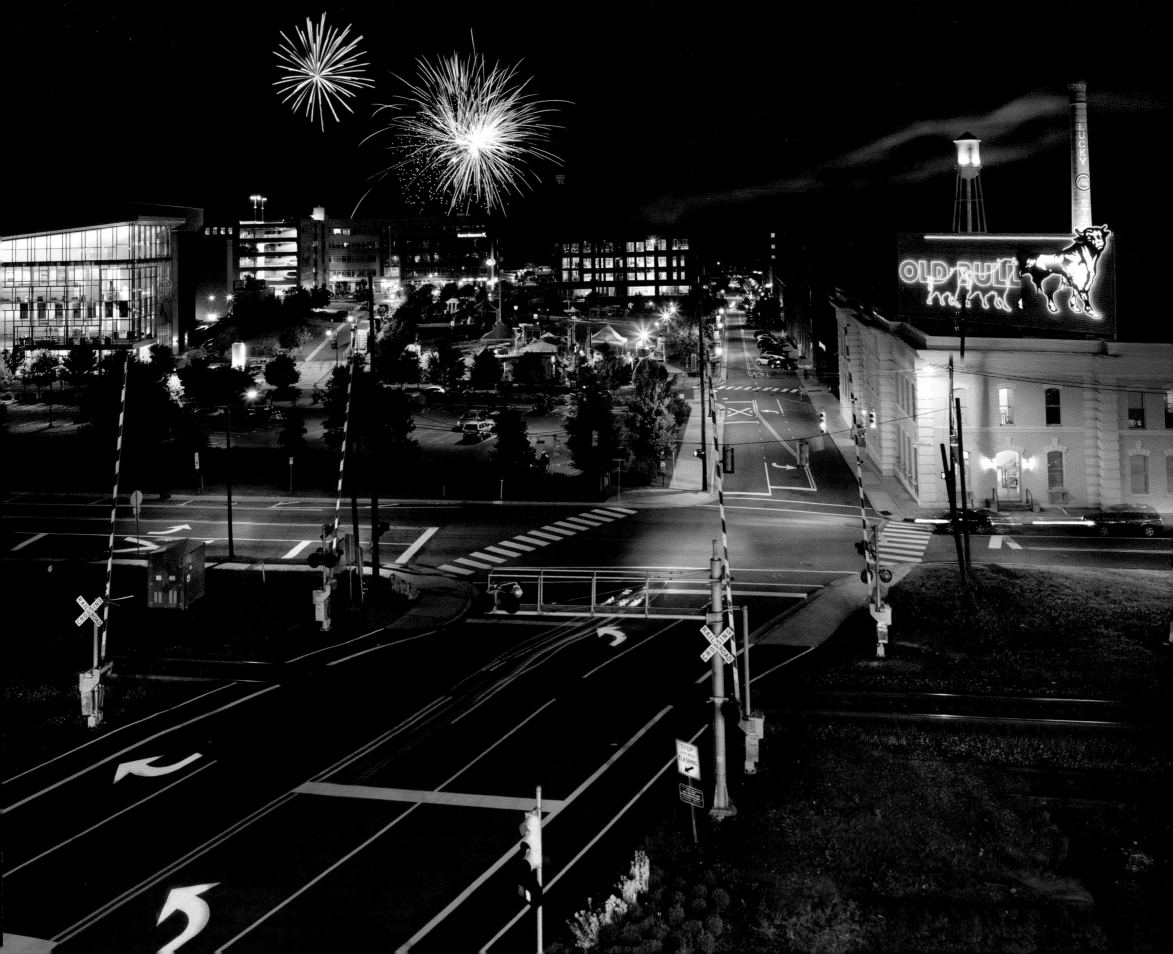

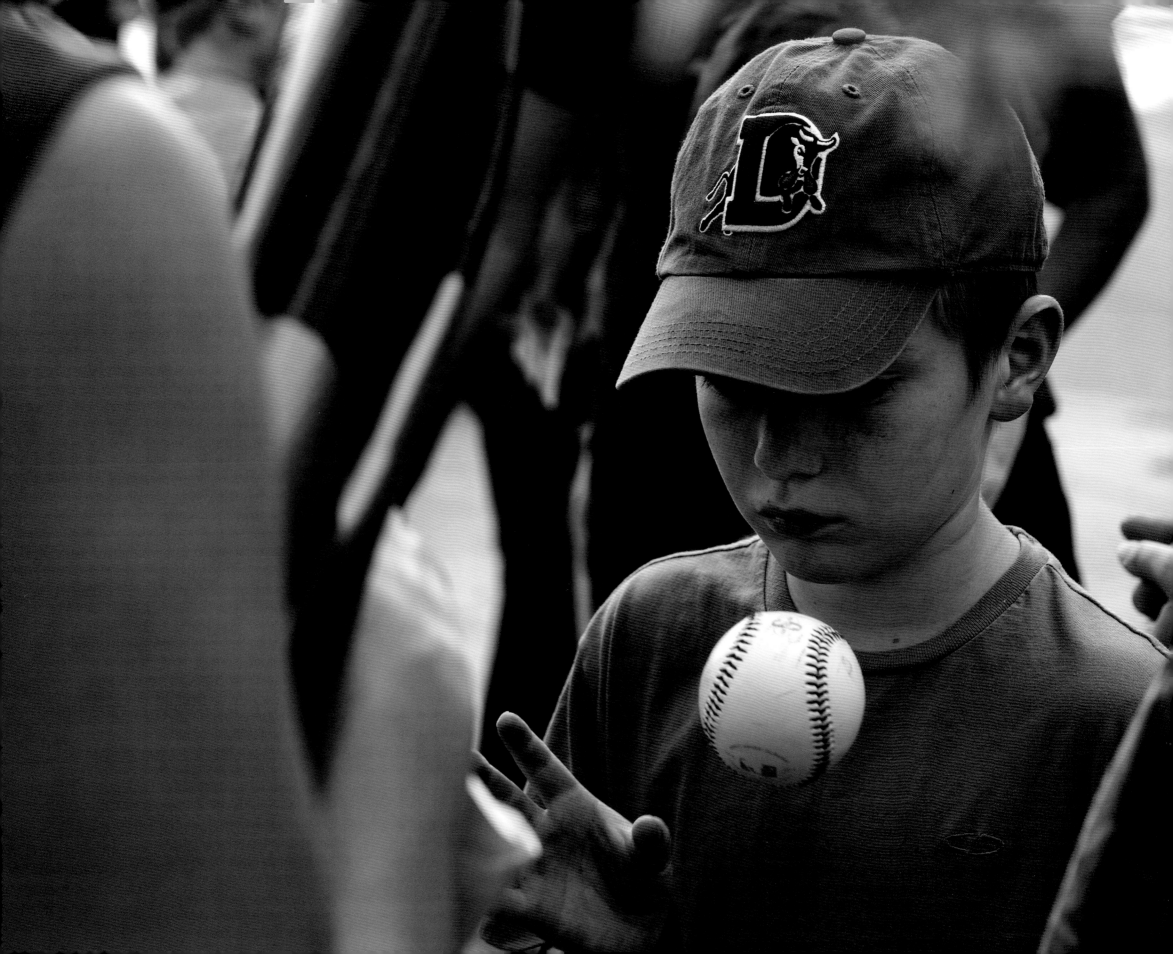

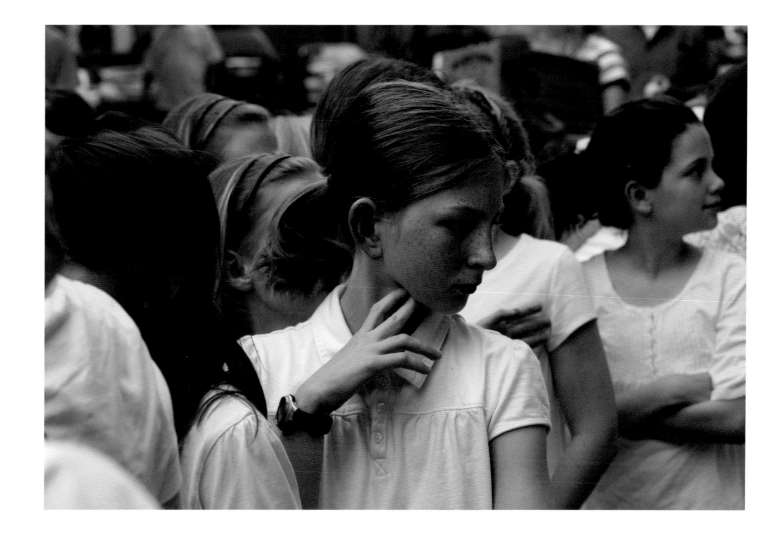

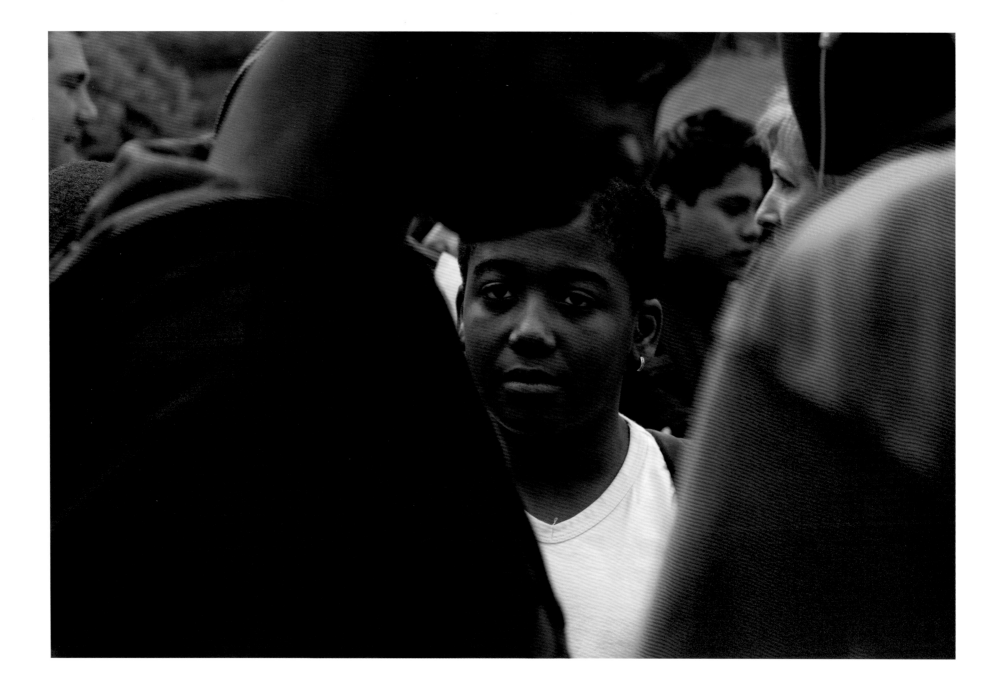

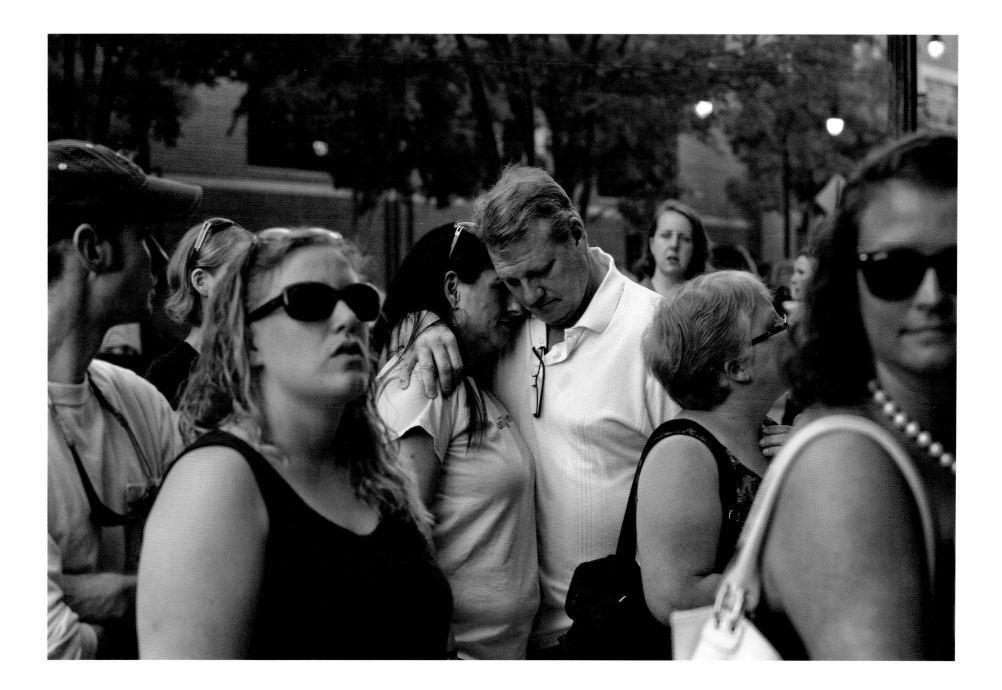

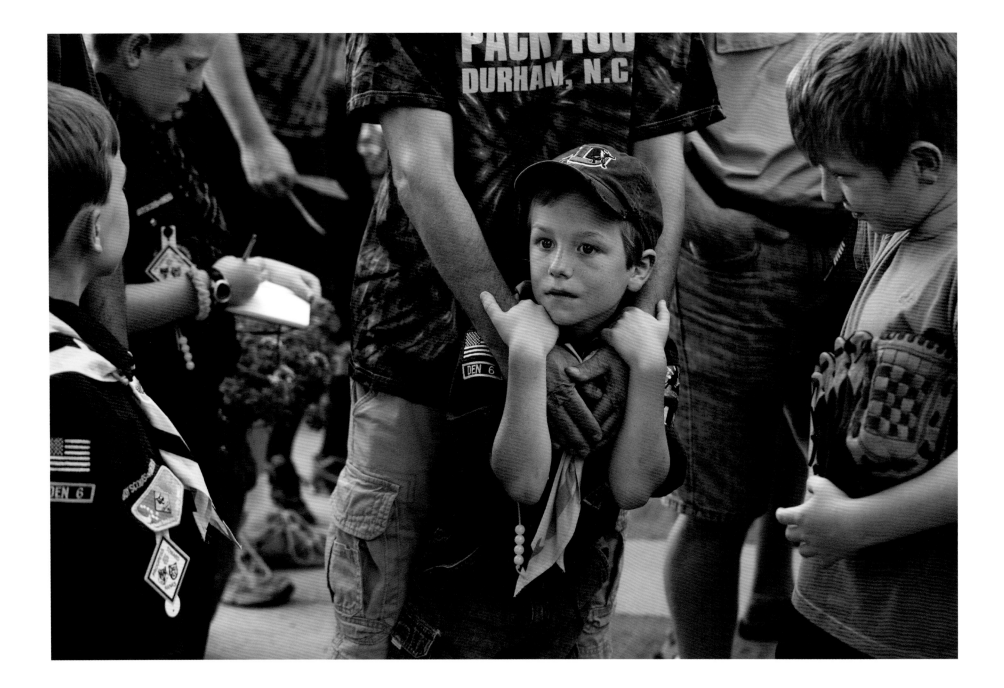

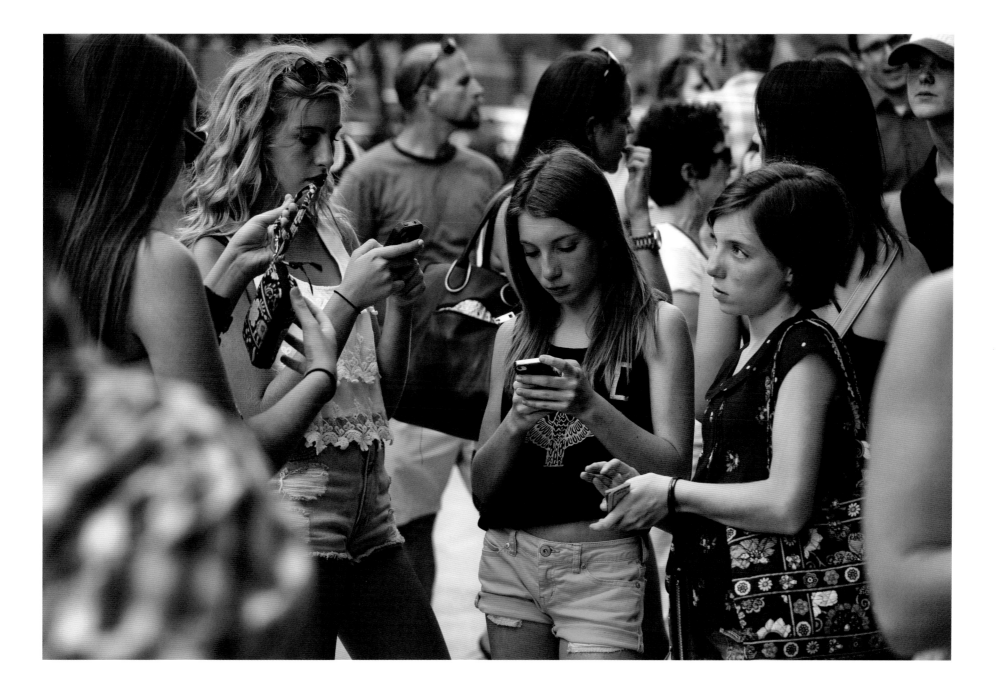

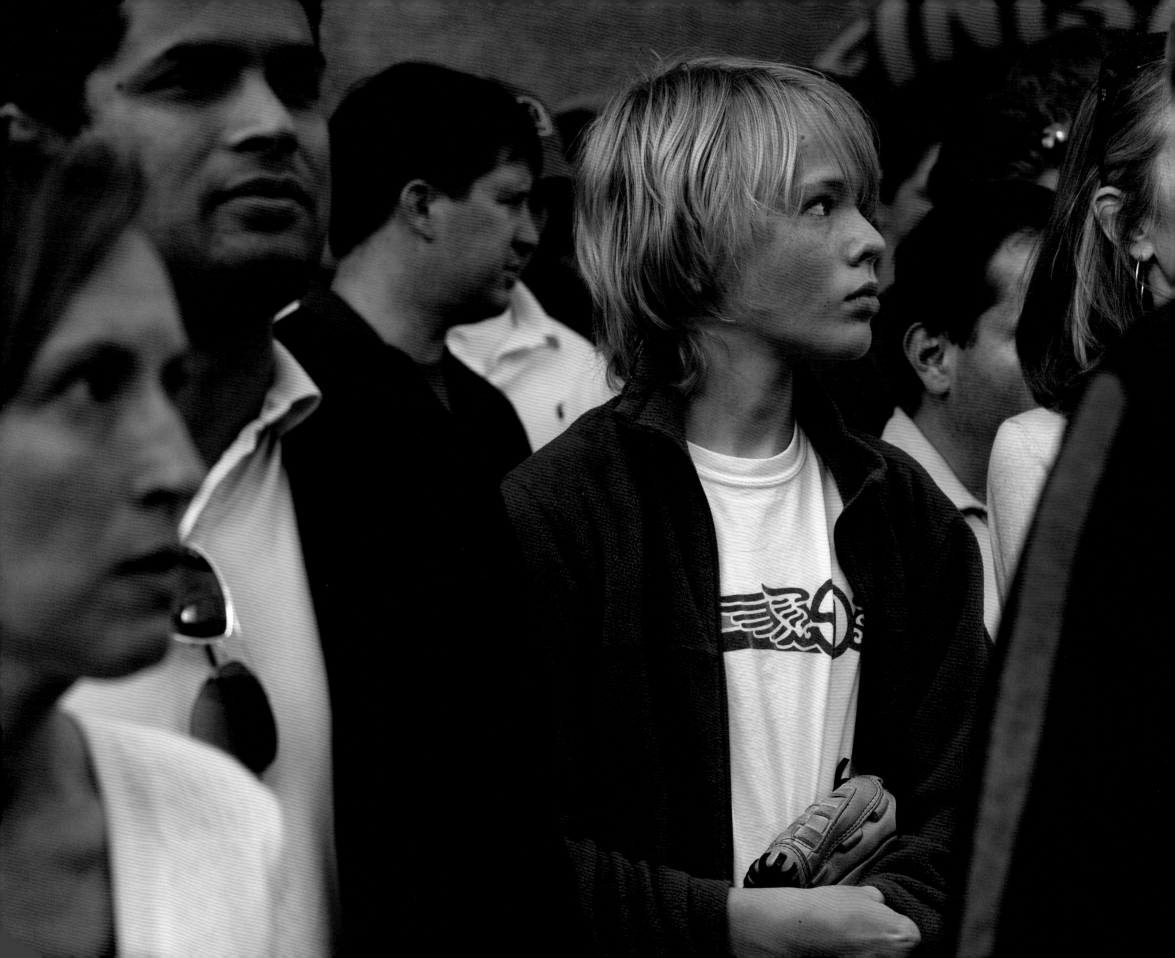

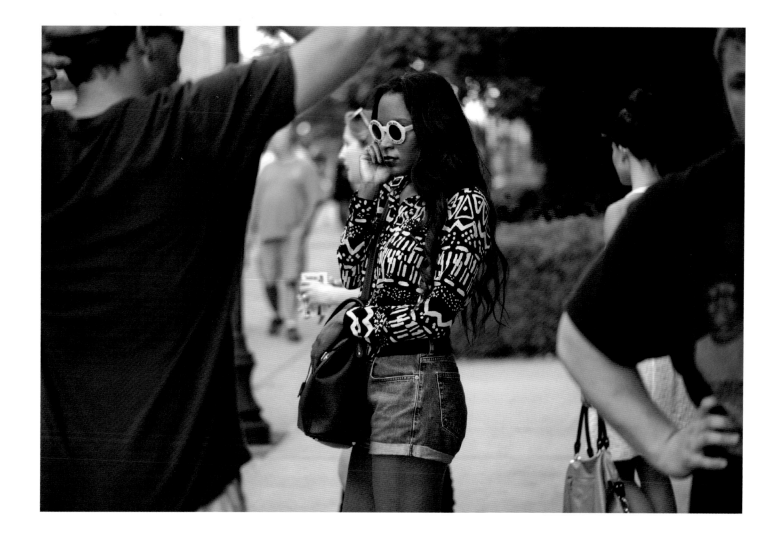

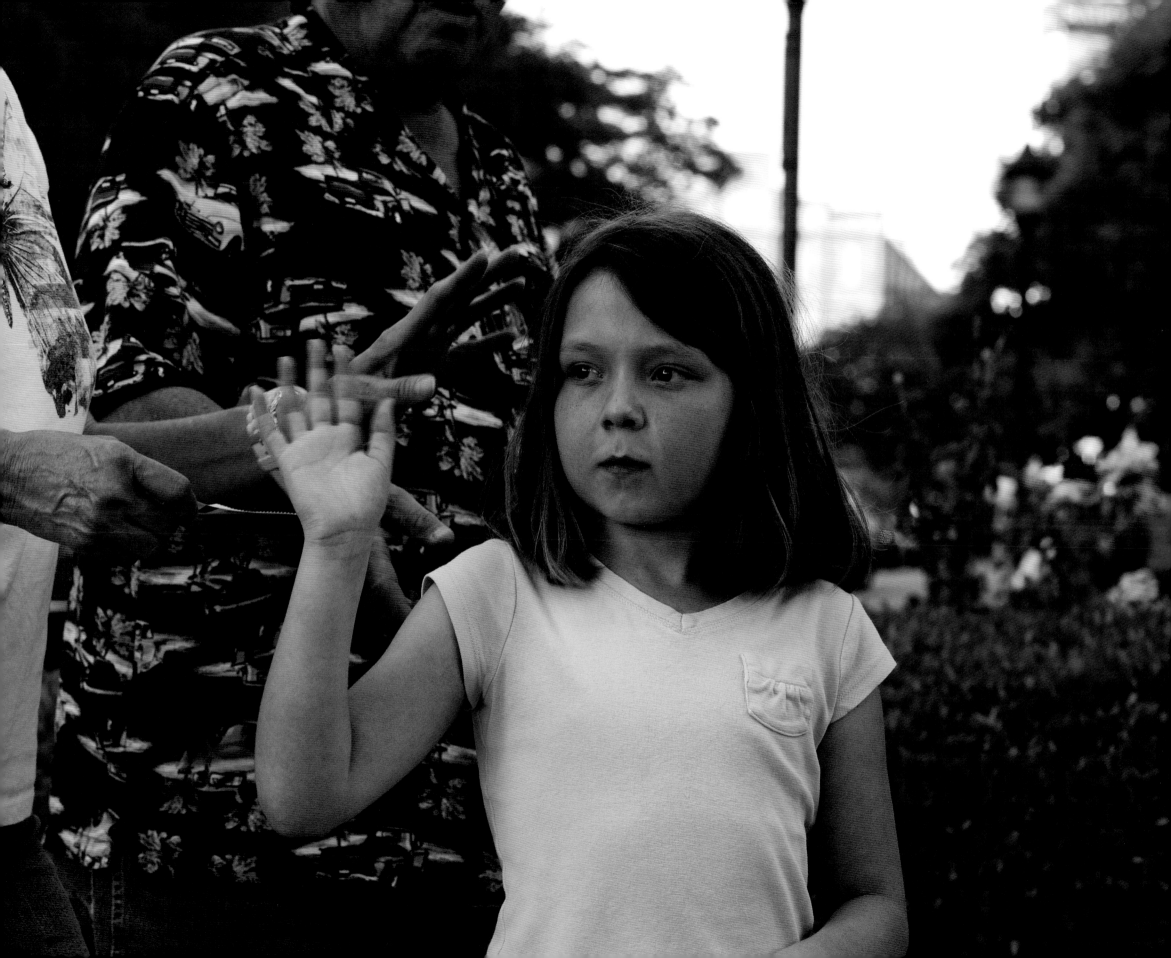

May 31, 2013.

Scranton/Wilkes-Barre RailRiders at Durham Bulls. Top of the 3rd.
2 outs, 0 balls, 2 strikes. Paduch strikes out Joseph looking.

Alex Harris
Frank Hunter
Kate Joyce
Elizabeth Matheson
Leah Sobsey

Alec Soth

Hank Willis Thomas
Hiroshi Watanabe

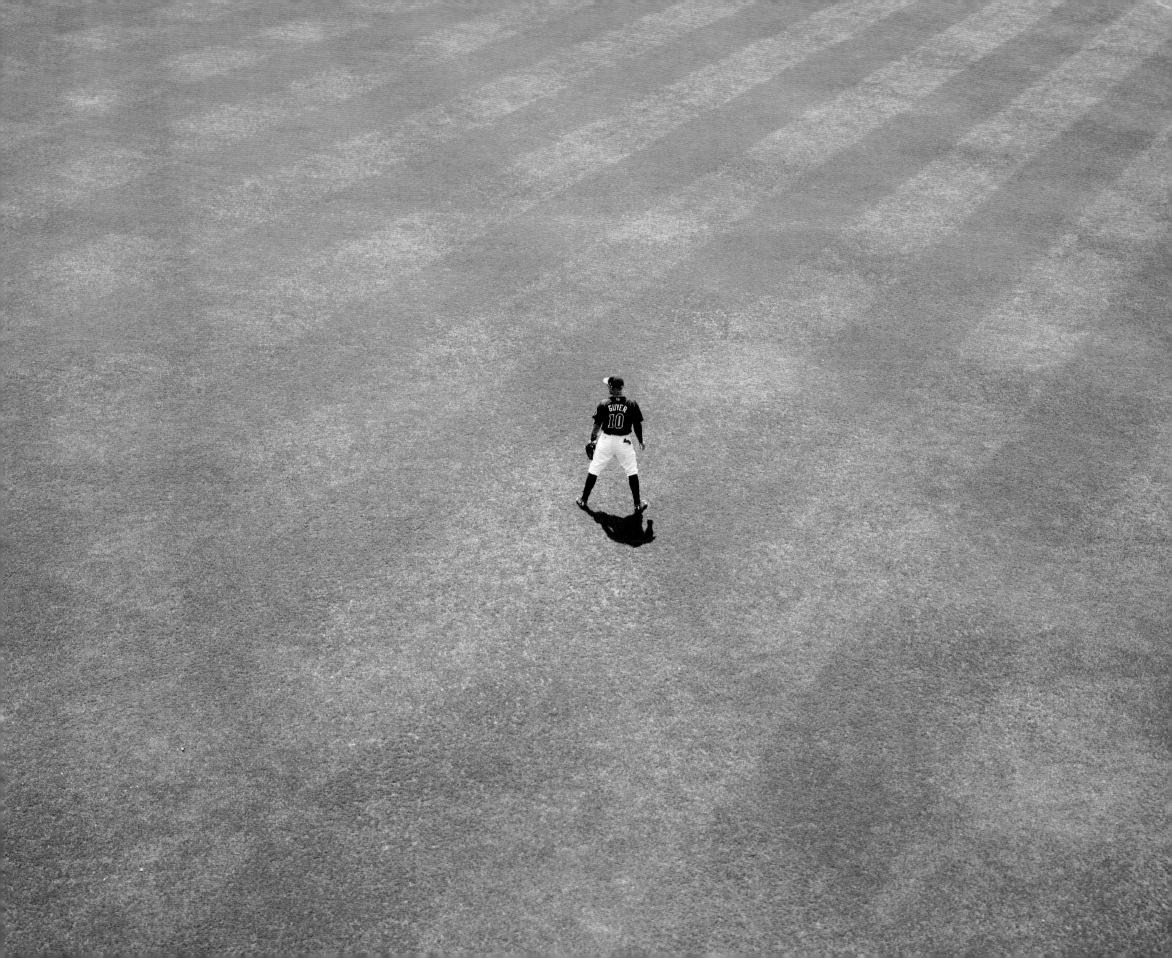

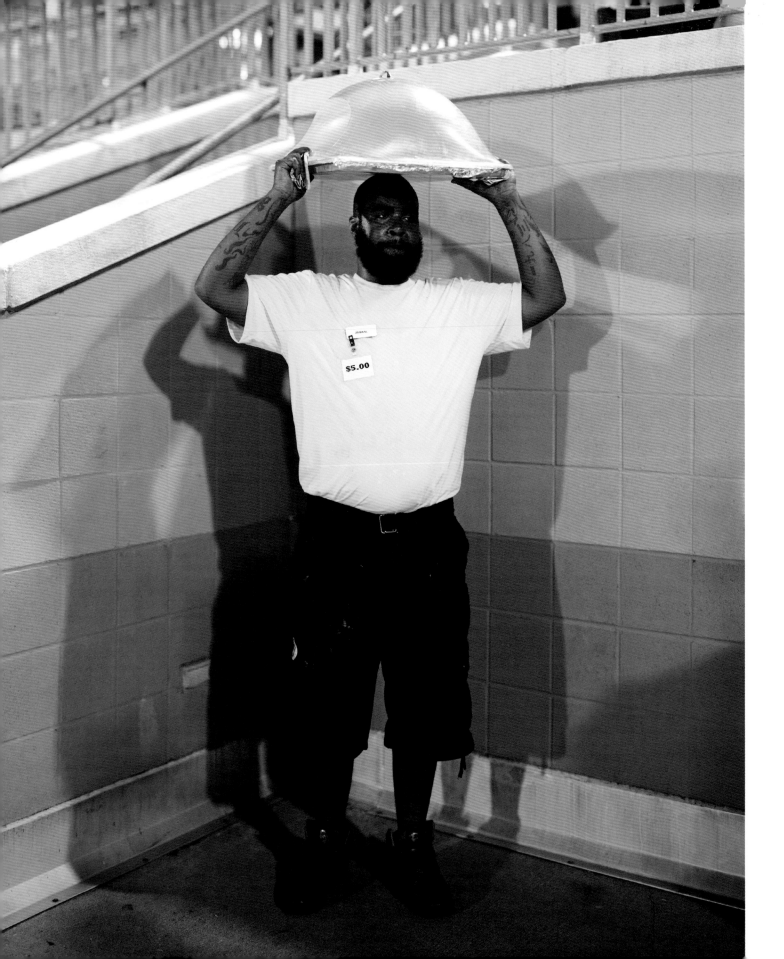

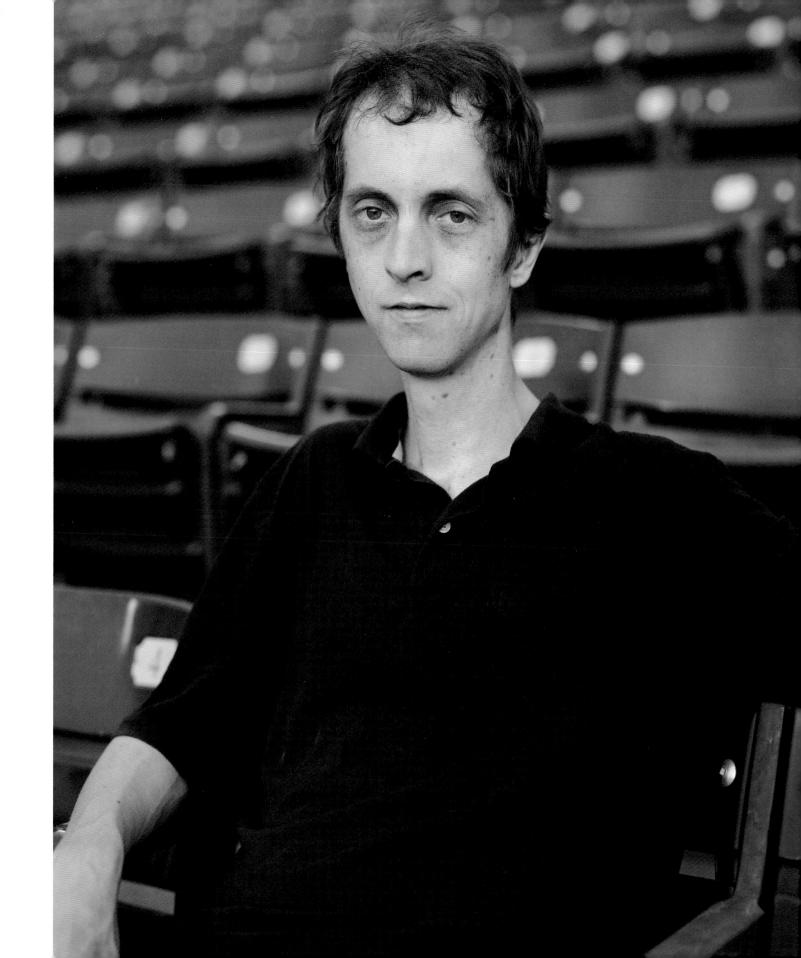

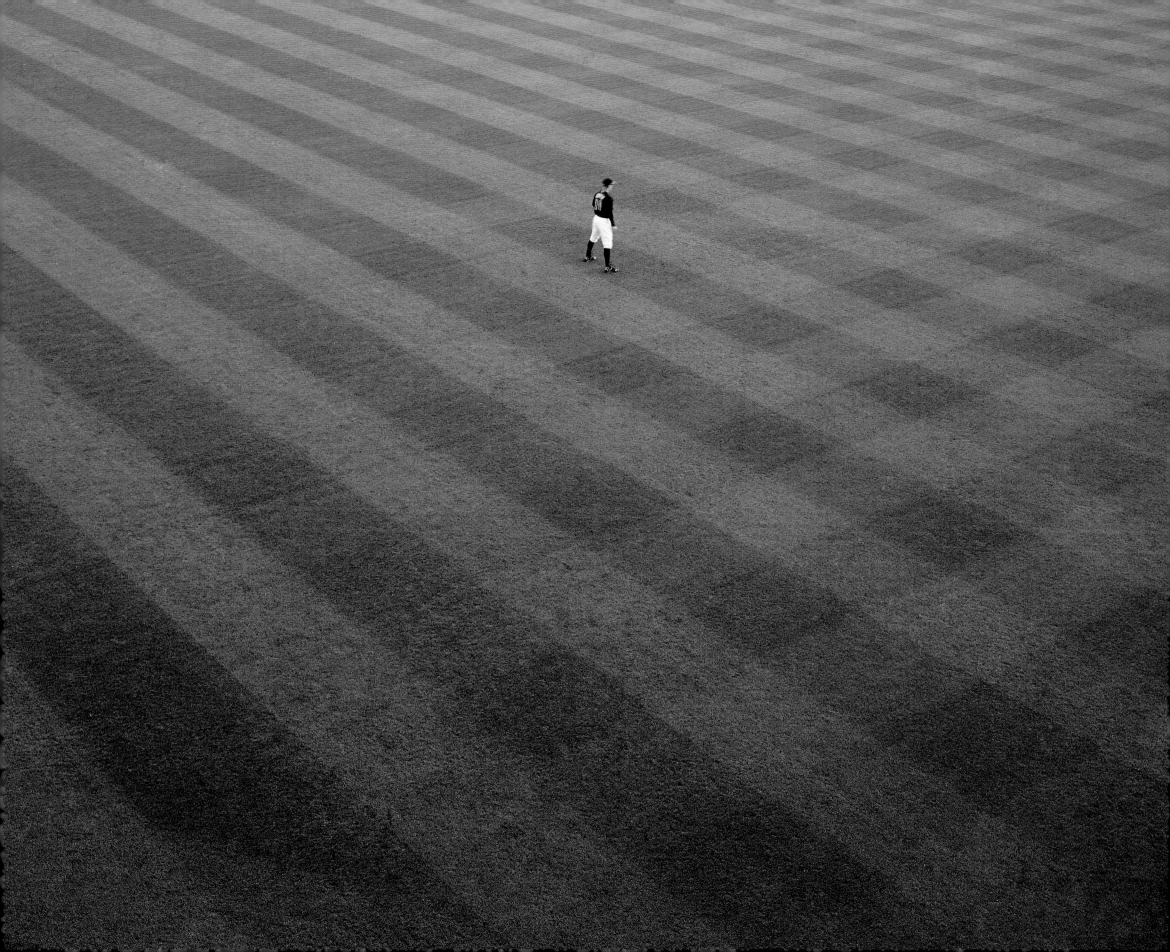

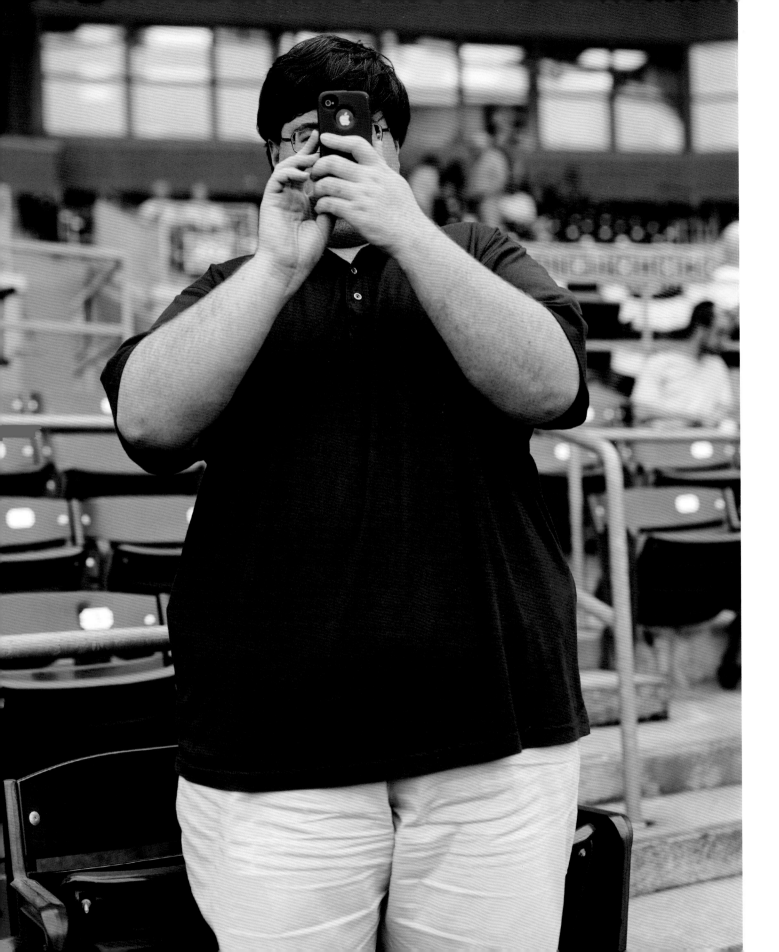

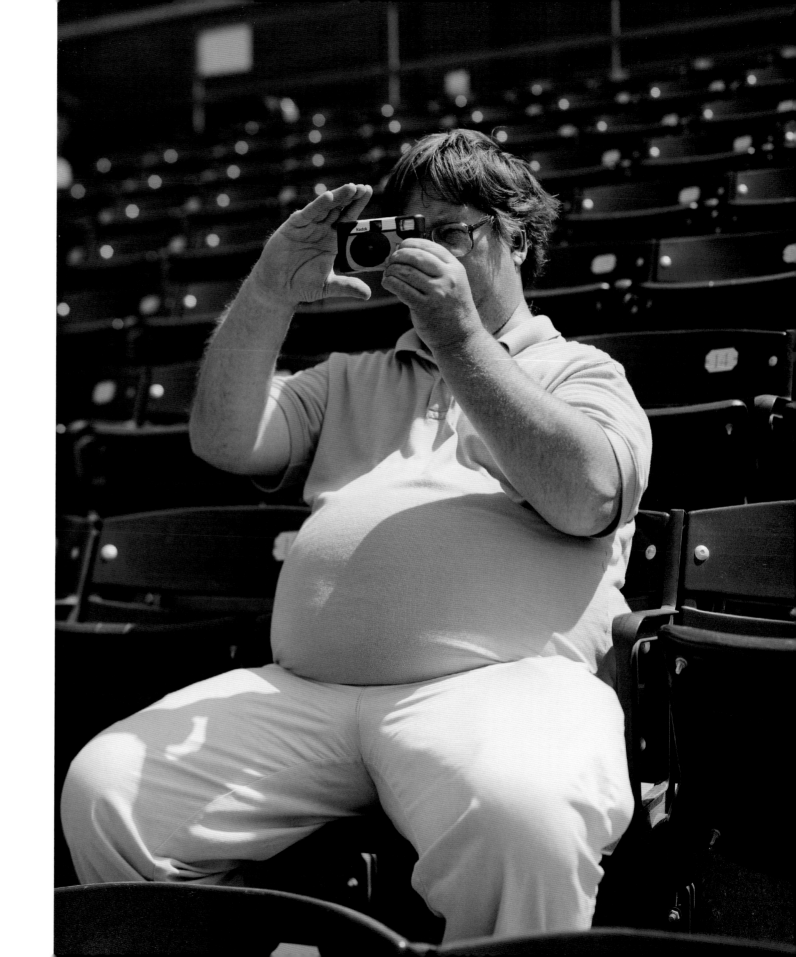

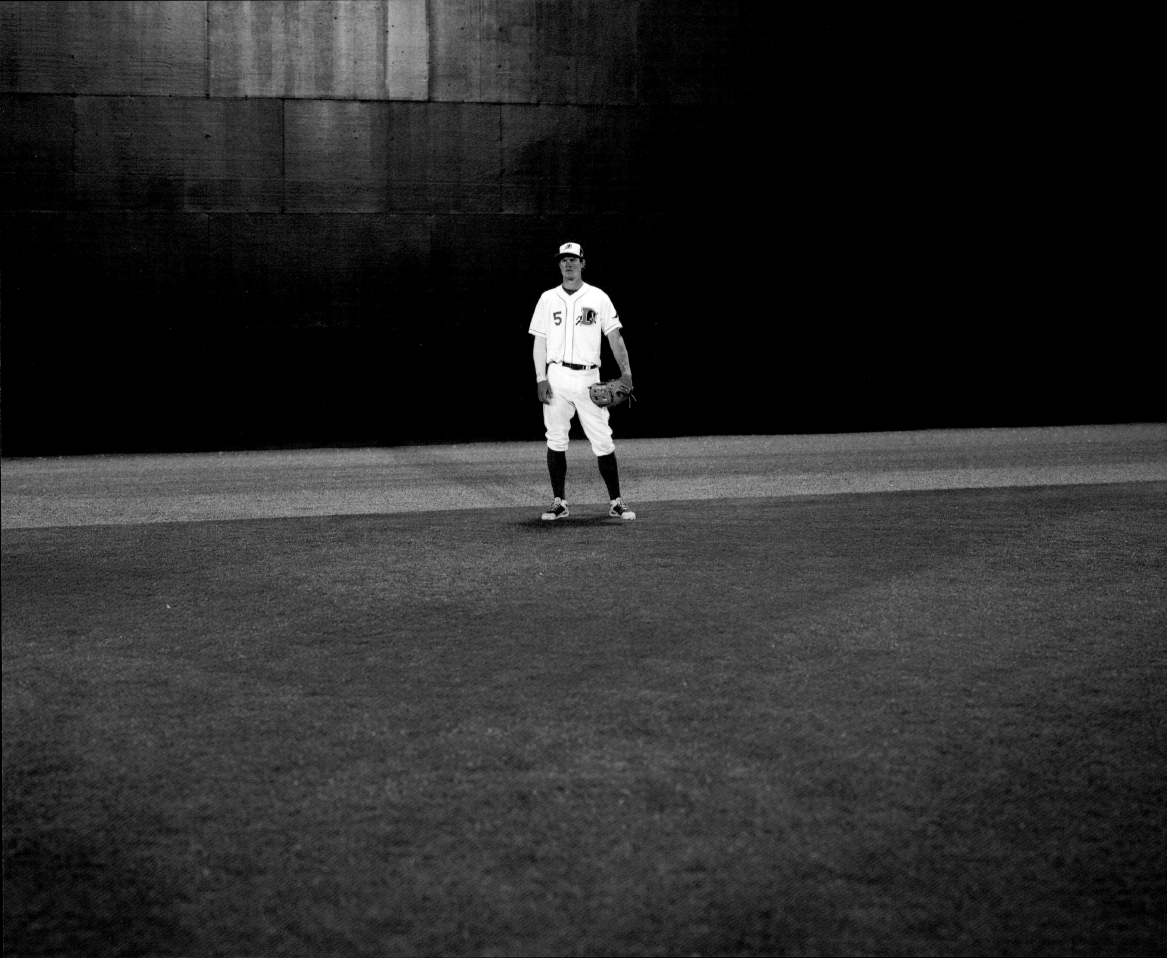

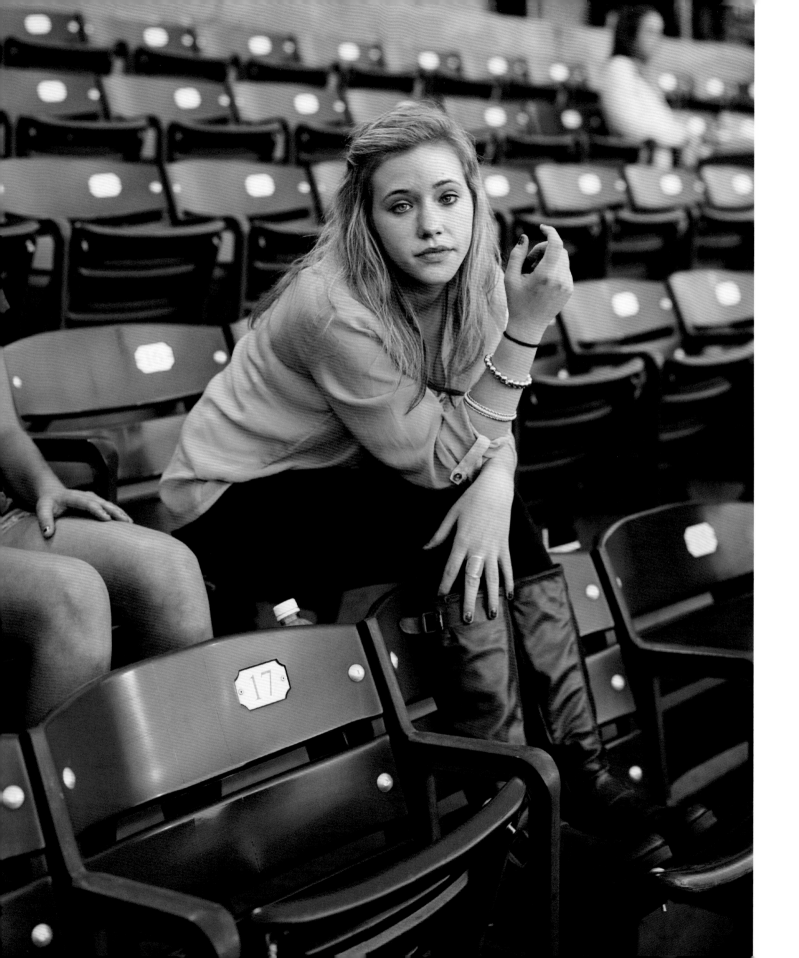

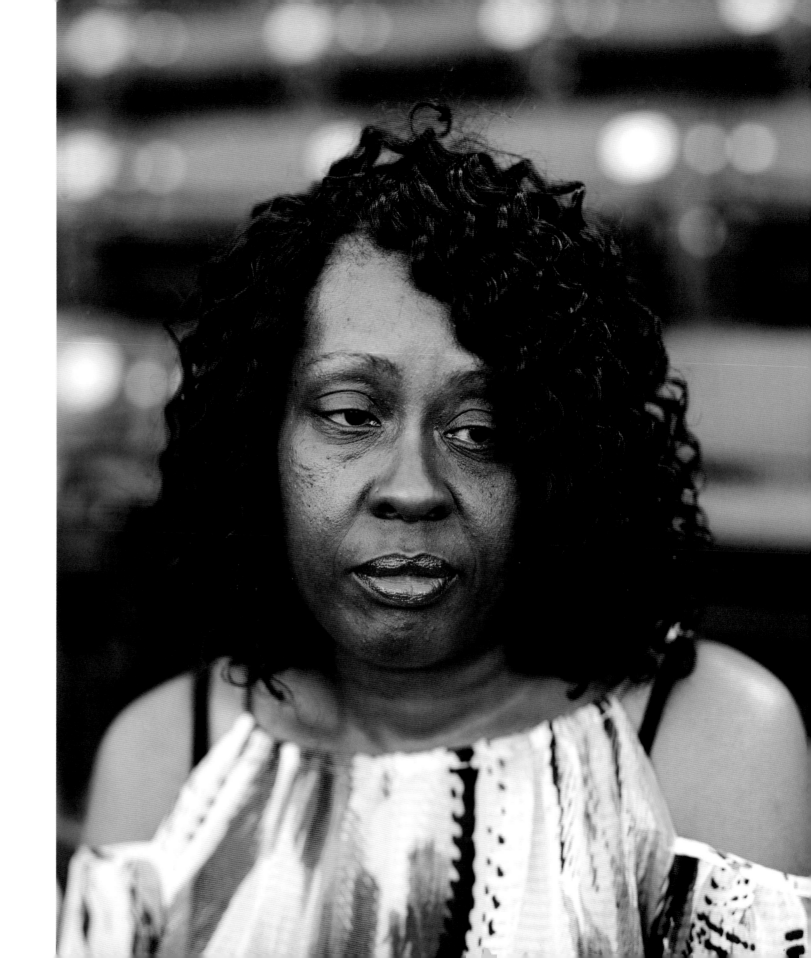

July 2, 2013.

Columbus Clippers at Durham Bulls. Top of the 1st. No outs. Full count.
Kelly walks Carrera, Carrera steals 2nd, Carerra advances to 3rd on Kelly's
wild pitch.

Alex Harris
Frank Hunter

Kate Joyce

Elizabeth Matheson
Leah Sobsey
Alec Soth
Hank Willis Thomas
Hiroshi Watanabe

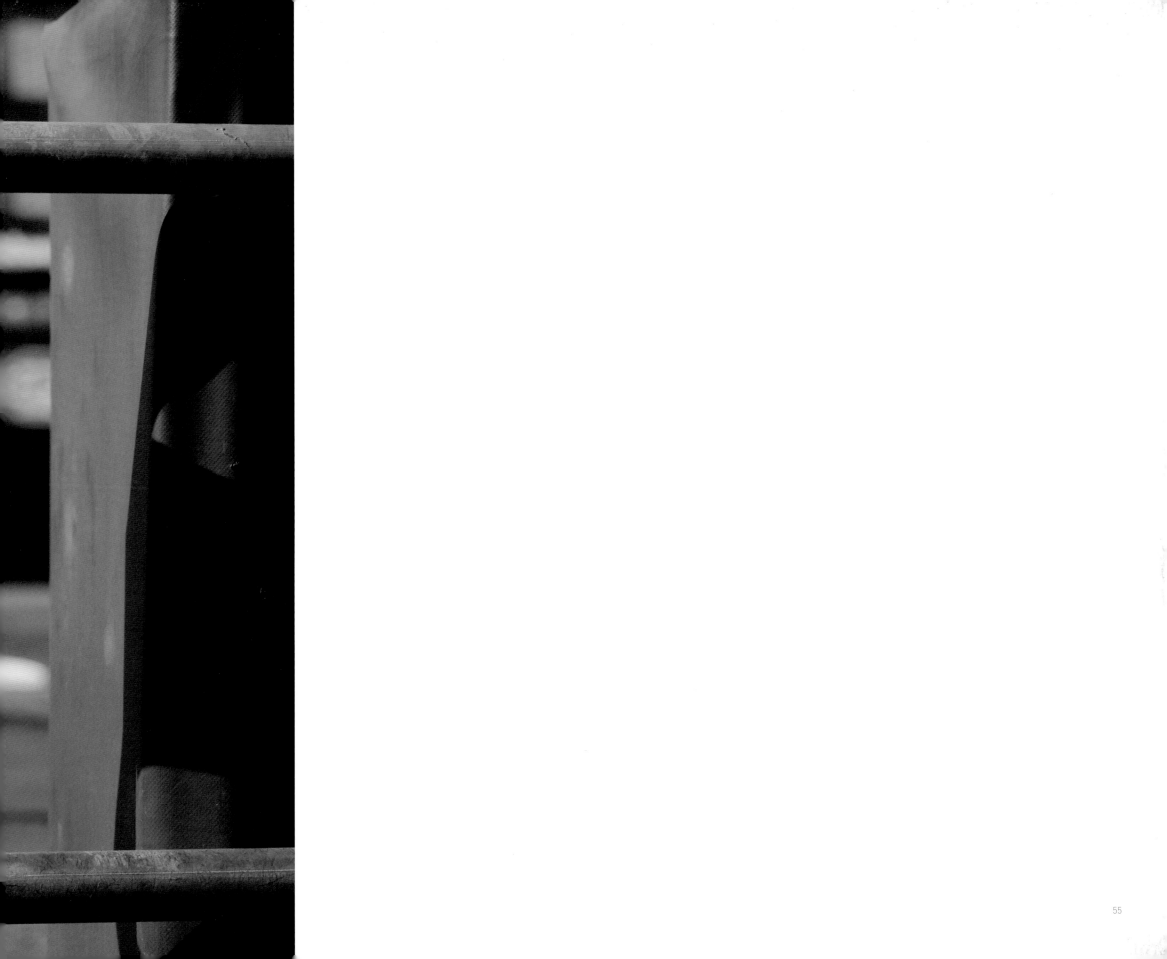

July 11, 2013.

Charlotte Knights at Durham Bulls. Bottom of the 2nd. No outs. First pitch. Fontenot singles to right field, Gimenez doubles to left field, Frey grounds out to 1st base, Fontenot scores:

Bulls 3-1.

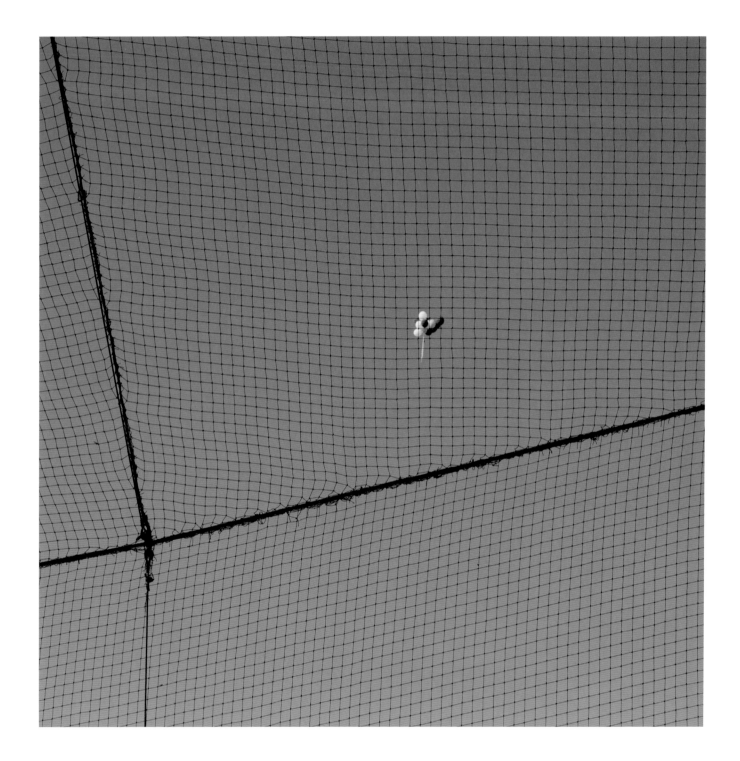

July 13, 2013.

Gwinnett Braves at Durham Bulls. Top of the 9th. 2 outs. Full count. De Los
Santos walks Boggs.

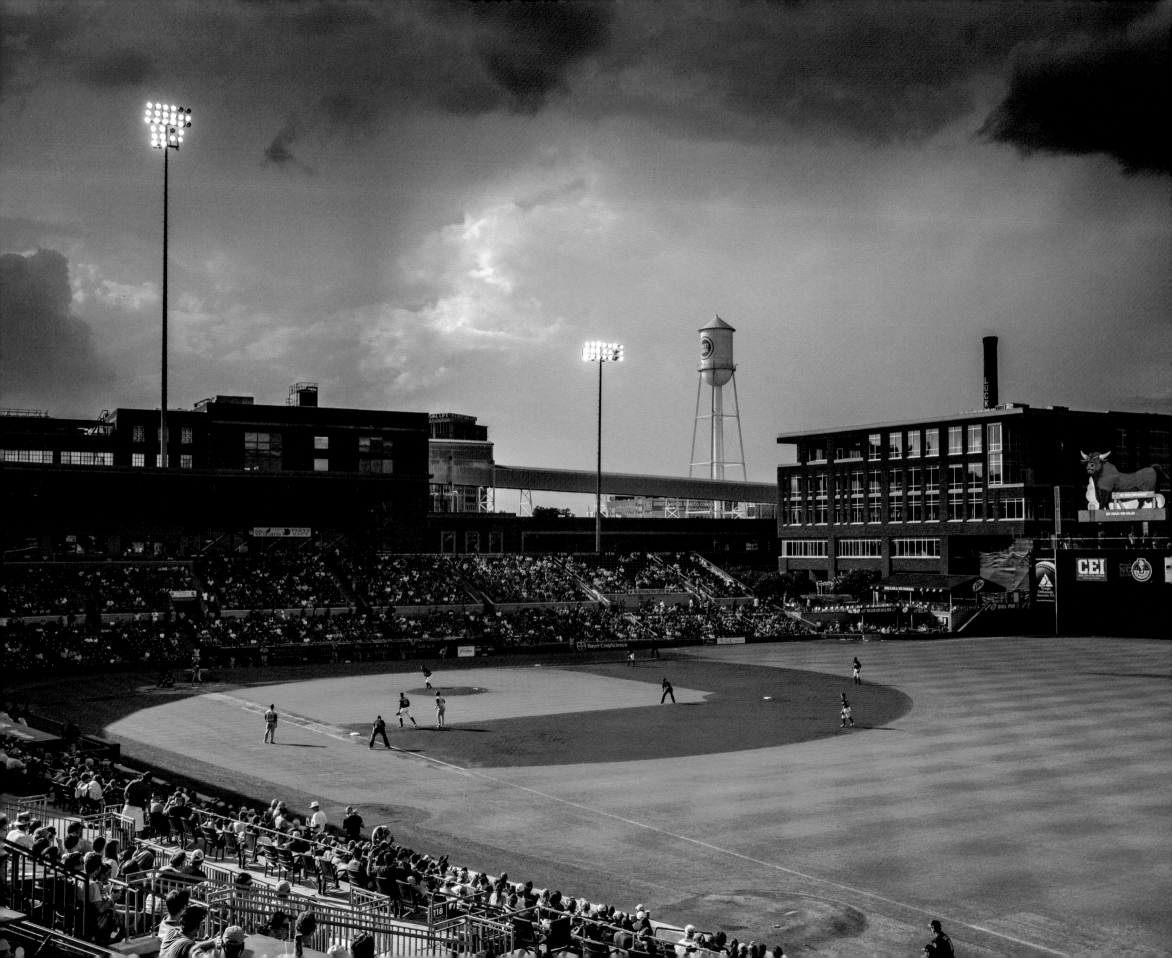

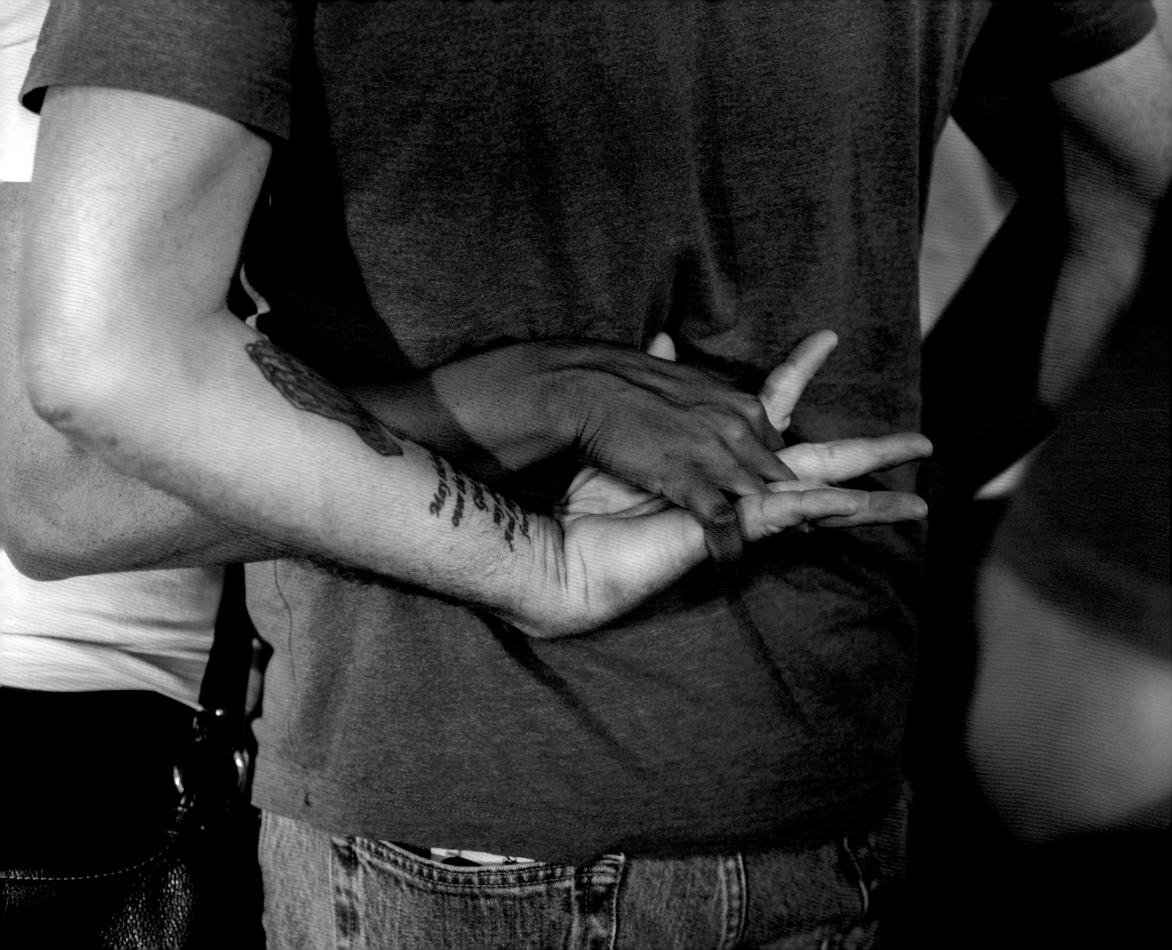

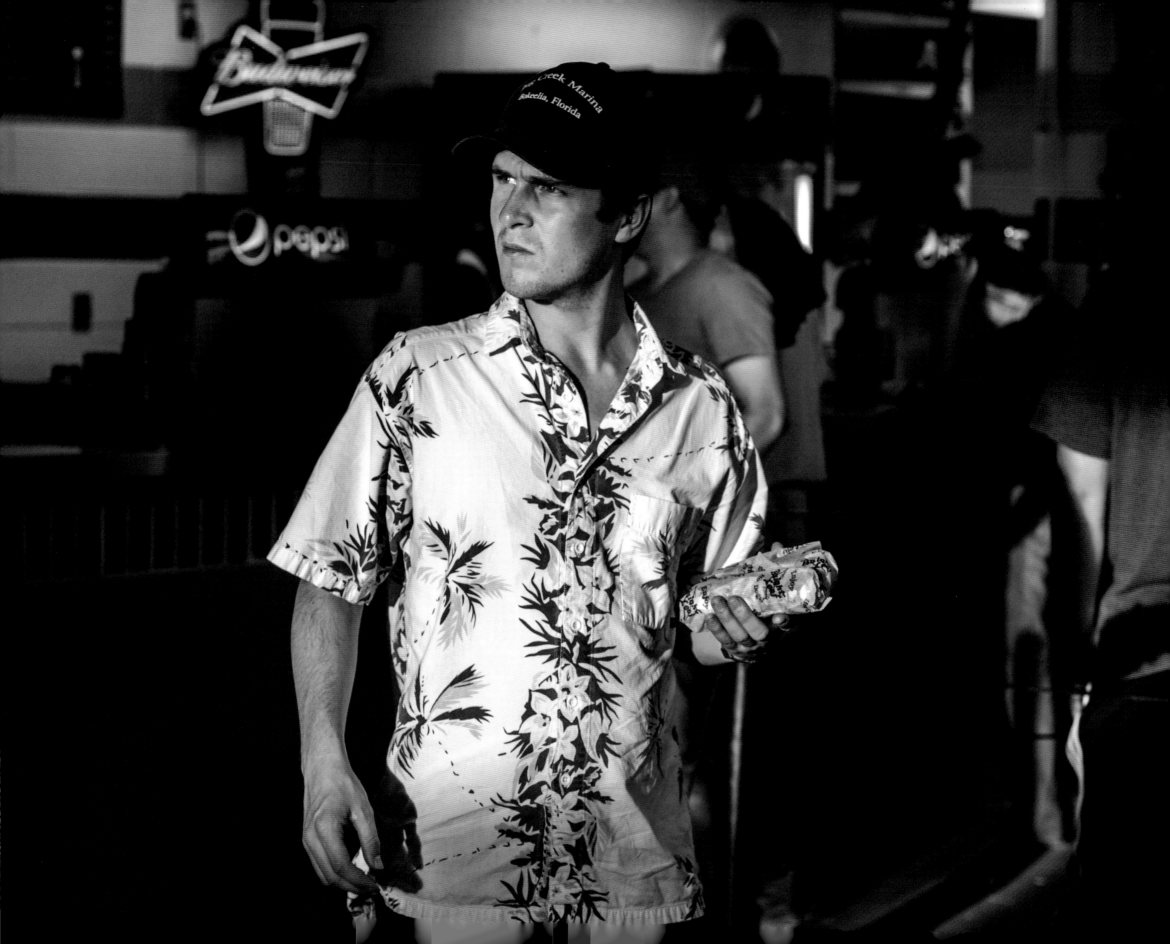

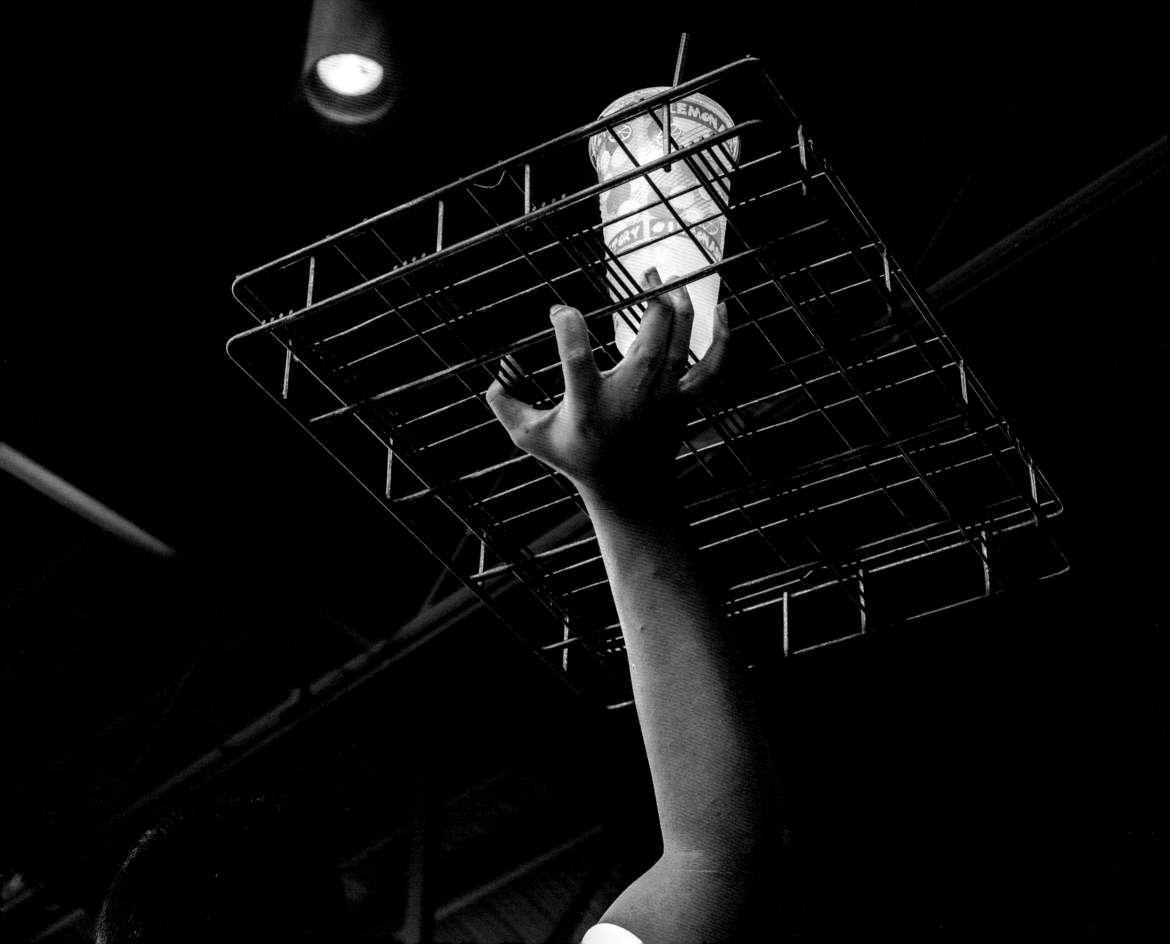

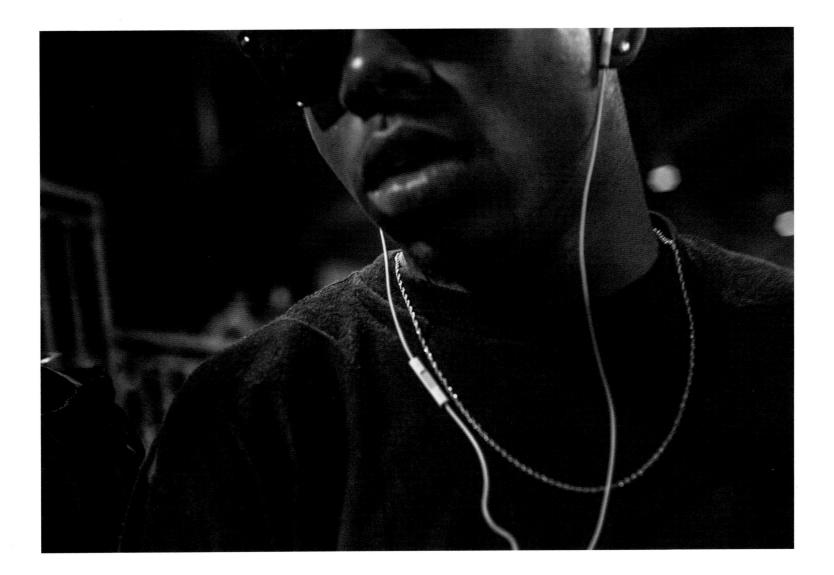

Alex Harris
Frank Hunter

Kate Joyce

Elizabeth Matheson
Leah Sobsey
Alec Soth
Hank Willis Thomas
Hiroshi Watanabe

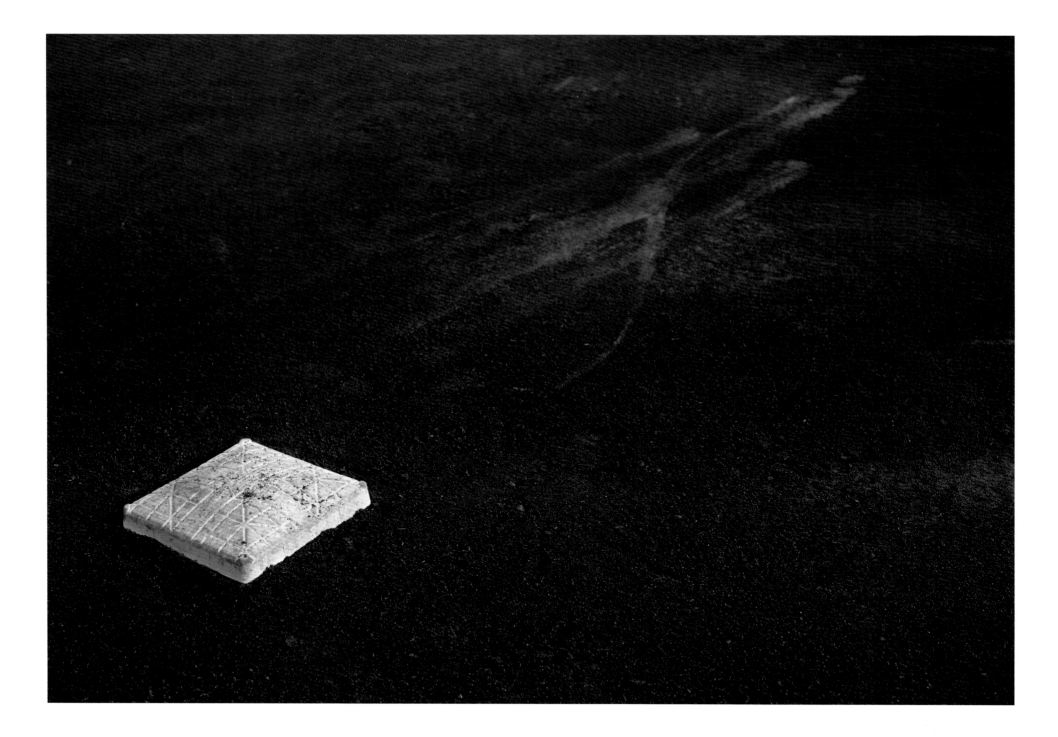

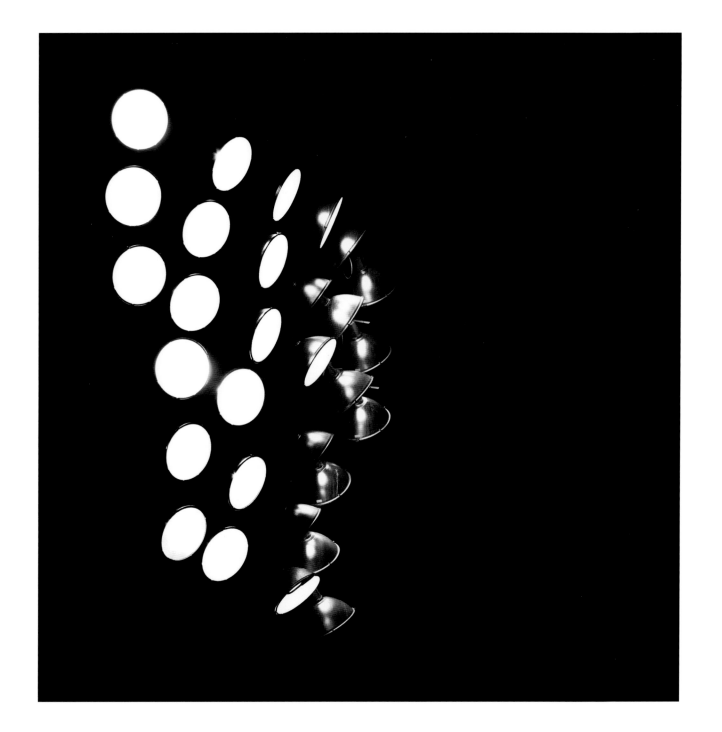

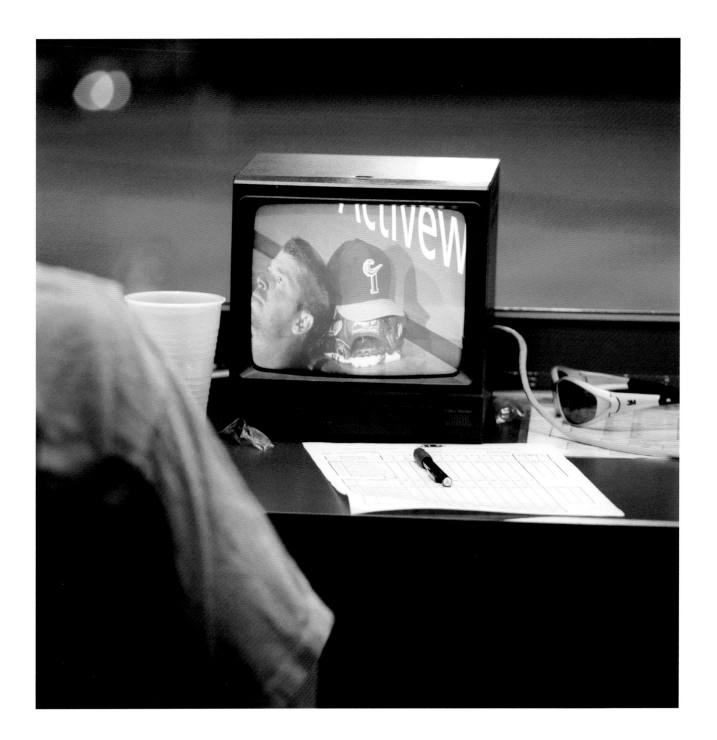

July 4, 2013.

Norfolk Tides at Durham Bulls. Top of the 2nd. No outs, 1 ball, 2 strikes
(3 fouls). Martin Strikes out Navarro swinging.

inning, stole second base as tasked, and scored the tying run. The Rays went on to win; in retrospect, they had to, even to have the chance to face Texas in Game 163. Guzman did not play in Game 163, or ever again for Tampa Bay. A single game, a single *base* from Guzman—whose last name, fittingly, immediately follows Guyer's in the alphabetical list of professional ballplayers—was worth two months of Brandon Guyer. All of that, just for this.

I didn't know about Guzman when I wished Guyer a good off-season and thanked him for his time this year, as I did with all the players who had been most amenable to speaking with me. I've always considered it a courtesy, not a requirement, of their job. Guyer returned the pleasantry: "Take care, Adam."

This jarred me. Guyer had never called me by name in three years. I didn't think he even knew it. In the five years I had covered the team and its scores of players, I probably had not been addressed by name more than five times. There's a sort of fourth wall there—probably a healthy one—and Guyer had just broken it.

I went out into the parking lot doubly braced—by this unexpected familiarity, even intimacy, and by the sudden autumnal cold. A few veteran Bulls, including Mike Fontenot, were hastily cramming their huge gear bags into the back of a taxi, like bank robbers with a getaway car. They zipped away. The hotel provided complimentary transportation. One shuttle had departed a few minutes earlier, but another was supposed to arrive any minute. Why had they sprung for a cab?

It turned out that they knew better. There were a few other Bulls still out there on the curb. They, too, had missed the first shuttle to the hotel, but 15 minutes later there was no sign of the next one. The players left behind, I noticed, had all very recently joined the Bulls from Double A, including Enny Romero. They stood in a bemused, tentative cluster.

The difference was suddenly so clear. It wasn't just that the Triple-A guys were older and wiser. Had this been the major leagues, where the players are older still, there would have been a fleet of transportation, luggage handlers, chartered flights. In Double A, there probably would

have been the usual overnight bus, waiting to leave until every last man was accounted for. But here in the Triple-A netherworld, the neither/nor world, there was neither luxury nor lookout. You got to stay at the resort, but it was in Allentown, and you had better get yourself there. You might get called up, but you may never play. You might get real major league money, but for a fake minor league injury. You were caught between a rock and a rock star.

"It's a game of adjustments"—you hear that from ballplayers much oftener than "it's a game of inches." Adjusting is what you learn to do here, as you do in life.

As the taxi sped away from the ballpark on the season's very last night, the difference between Triple A and the rest of baseball suddenly became so clear: You have to be smarter to survive Triple A than anywhere else.

July 4, 2013.

Norfolk Tides at Durham Bulls. Top of the 1st. 2 outs, full count. Urrutia doubles to center field.

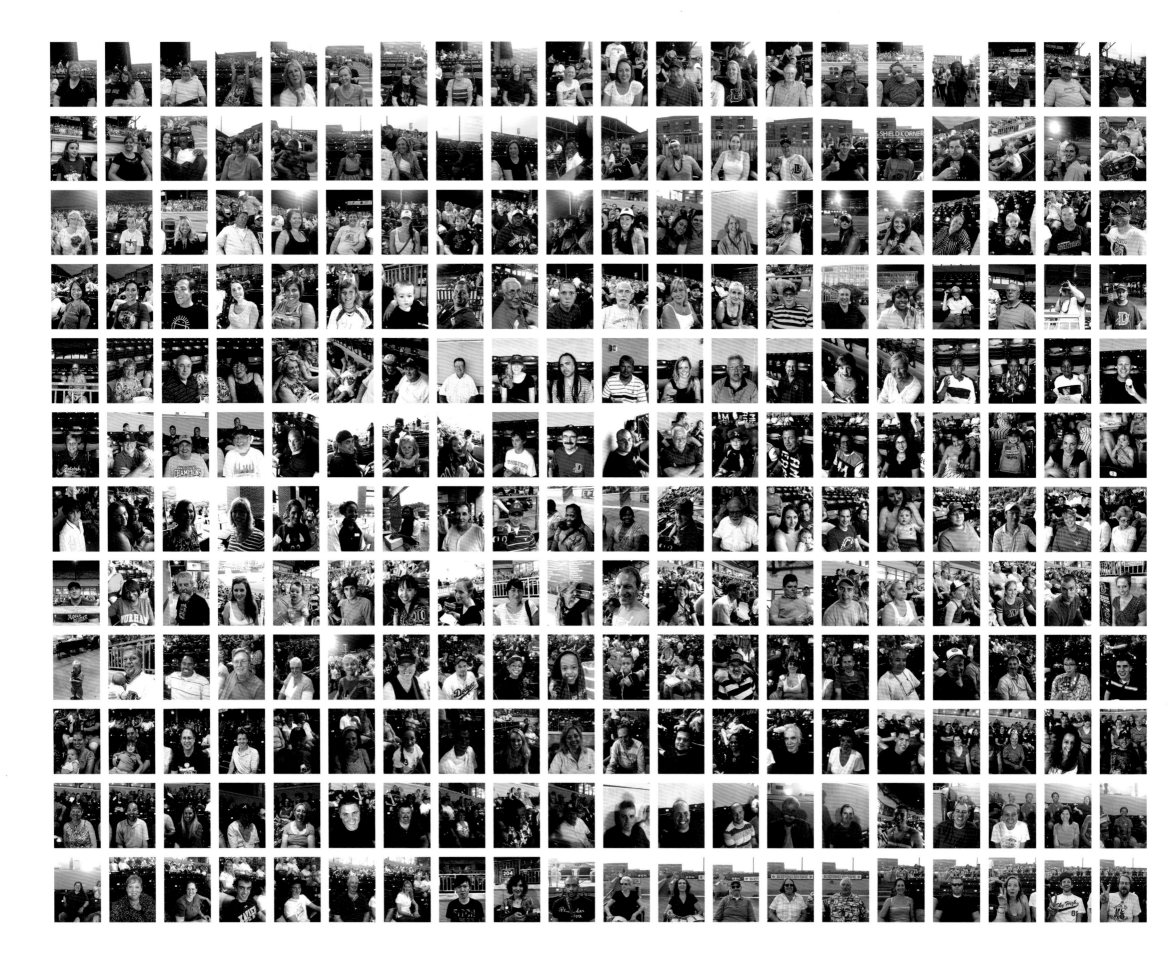

sometimes hallucinogenic, indicating its roots in ritual music.

Montoyo keeps a large collection of congas, bongos, and various other salsa percussion instruments in the home he shares with his wife, Samantha, and their two young sons, Tyson and Alex. He listens to the music through his earphones while playing the instruments in the garage. Without hearing the full ensemble—the brass and vocals on the front line—says Samantha, the neighbors can't comprehend the rhythms coming from Charlie's hands.

July 21, 2013.

Pawtucket Red Sox at Durham Bulls. Bottom of the 1st. 1 out.
Full count. Webster walks Gimenez, Gimenez scores on Anderson
(designated hitter) double:

Bulls 3-0.

Alex Harris
Frank Hunter
Kate Joyce
Elizabeth Matheson

Leah Sobsey

Alec Soth
Hank Willis Thomas
Hiroshi Watanabe

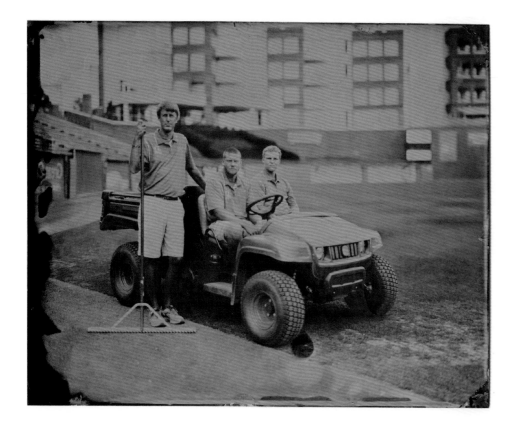

Leah Sobsey/Tim Telkamp. Tintype.

Groundkeepers. L-R. Scott Strickland, head groundskeeper;
Connor Moser; Bill James.

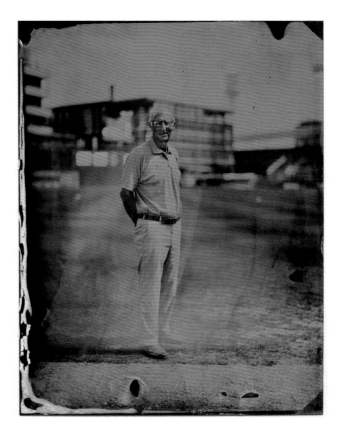

Leah Sobsey/Tim Telkamp. Tintype.

Dr. Richard F. Bruch. Bulls team doctor since 1980.

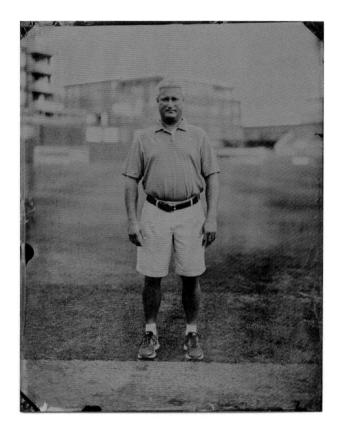

Leah Sobsey/Tim Telkamp. Tintype.
Mike Sandoval, trainer.

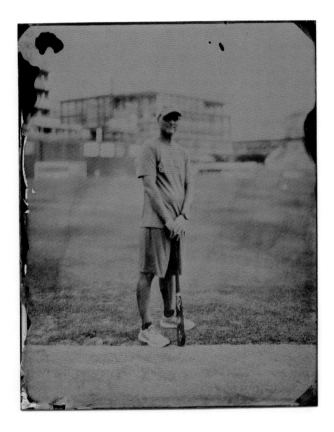

Leah Sobsey/Tim Telkamp. Tintype.
Mike Birling, general manager.

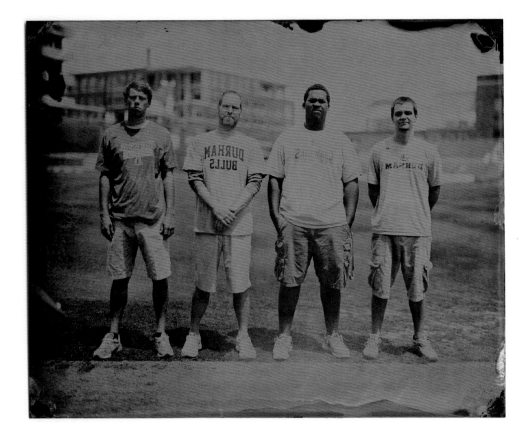

Leah Sobsey/Tim Telkamp. Tintype.
Clubhouse attendants. L-R. Ryan Schanz; Colin Saunders, head clubhouse attendant; Daniel Jordan; Danny Willis.

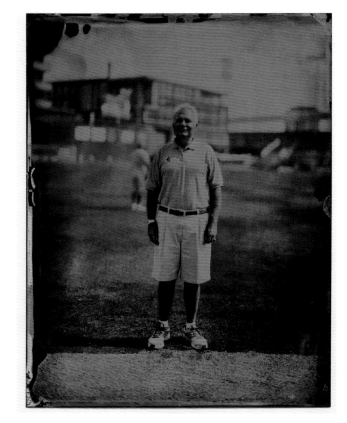

Leah Sobsey/Tim Telkamp. Tintype.
George Habel. Vice President. Sports Group. Capitol Broadcasting Co.

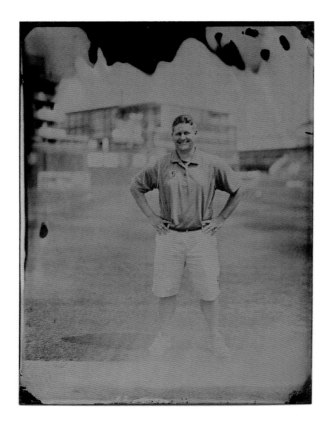

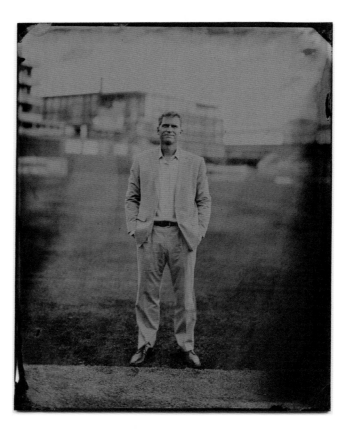

Leah Sobsey/Tim Telkamp. Tintype.
Scott Carter, director of marketing.

Leah Sobsey/Tim Telkamp. Tintype.
Chip Allen, director of corporate partnerships.

July 16, 2013.

Indianapolis Indians at Durham Bulls. Bottom of the 5th. 1 out, 0 balls,
1 strike. Belnome singles to left field, advances to 2nd base on Anderson
single, advances to 3rd base on Gimenez flyout.

A NOTE ON PROCESS

Ivan Weiss

Perhaps it's appropriate that the final section in a book dedicated to the still image and the written word comes from a video guy. While the vast bulk of what I shot this summer can't be shown here, I spent a large amount of time observing the photographers as they worked, shooting material for a documentary about them. So if there is one thing I am uniquely qualified to provide on this subject, it's perspective.

"How postmodern of you!" is an oft-heard reaction when I tell people what I've been up to. Appropriately, there are several photos of photographers taking photos of someone taking photos of me taking a photo—or some configuration thereof.

Despite the camera-happy symphony, I tried to approach my work without focusing too much on the medium. I followed the photographers in the same way I might document a carpenter building a table, or a scientist performing an experiment. The idea was to pull back the curtain on the creative process, show the nuts and bolts of what goes into an artistic vision, and demystify the hushed aura that all too often separates us from the finished work. Which, in this case, is the book you're holding.

It is no light matter for an artist to let someone else into her or his creative process. Photographers in particular expend copious amounts of time and energy trying to disappear. Alex Harris recalls that, when younger, he wished he could be invisible in order to get more intimate shots of subjects. Alec Soth describes a more dire feeling: that when he's looking for a photographic subject, people see him as a terrorist in search of a target. Kate Joyce once showed me a collection of her photos showing people giving her weird, cold, castigating looks. I am no stranger to this distrust. In fact, one of my photos shows *Bull City Summer* contributor Hank Willis Thomas giving me a biting glance!

As a photographer, half the battle is getting people to trust and then forget you. So why allow a creepy bearded dude with a big-ass camera to make your life that much harder?

Monday, May 6, 1:28 p.m. A slow, snotty rain drenches the baseball field, which has been covered with a protective tarp held down by three John Deere service vehicles. It is a surreal scene, and a lithe woman with short brown hair is bundled in a gray rain jacket and crouching in the stands behind home plate. Her camera is directed at an indeterminate point out on the field.

This is Kate Joyce, a native of New Mexico and current resident of Chicago, who has been working on the *Bull City Summer* project over the course of three summers. About 20 feet behind her stands yours truly, trying to capture video that might give a clue to what she's up to. Whether or not the camera can see it, I surely can't, and I ask her about it a few moments later.

"Recently I've been thinking about how different the interior of the park is from the exterior," she says. "So today in the rain I saw this building reflected in the water that's pooling, and I thought I could get at that idea.... I was also just playing around."

I follow Kate to the outer reaches of left field, to what is referred to in the Bulls' vernacular as "The Blue Monster." It is in reality the protective matte

covering the back wall. Kate wants to see if the rain has washed away the marks the baseballs leave when they ricochet off it. As we walk onto the field, she points at a small circular dusty area—the faint impression of what must have been a very hard impact. For about 15 minutes, I shoot footage of Kate from a number of angles as she photographs these traces in the process of being washed away. It is a strangely poignant moment.

Amid the summer rain, the Bulls grounds crew is setting up a fence in right field. The fence is there to protect a large video screen during batting practice. Like many an activity at the stadium, it is a ritual performed before every home game.

Today this work seems particularly arduous, yet the crew is in good spirits, joking about how they're being covered by the paparazzi and we should use this material to put together an introductory video for new recruits. Kate laughs with the guys, but doesn't forget what she's there to do. She is not afraid to get up close and personal, at times only a few inches away from their necks, shoulders, the backs of their cheeks. As she performs her work, her thick, craftsman-like hands keep the camera

completely steady. The eye not in the viewfinder quivers like someone under a spell, riveted by the human forms before her.

I imagine that Kate and I are amusing and slightly bewildering figures to these men—as, in fact, we are to ourselves. At this early point in the season, Kate tells me she is still trying to figure out what her work at the stadium is all about. I am likewise trying to figure out what, if anything, documenting a photographer actually reveals. For the moment, I am able to forget my doubts and self-consciousness. Caught up in the frenetic activity, I start shooting the mounting of the temporary fence as if it were the raising of the flag at Iwo Jima.

Suddenly I turn my camera to find Kate snapping a picture of *me*. Caught in the act, she gives me a playful, apologetic smile, but then goes right on shooting my picture as I unconvincingly pretend not to be aware of her presence.

Wednesday, July 3, 2:26 p.m. A men's shower room in near total darkness. I am alone with Los Angeles-based photographer Hiroshi Watanabe. I can't see him, but I hear him breathing. Every

few minutes a flash goes off, yet it doesn't provide me, or my camera, enough light to see what he is photographing.

The locker room is one of the main spaces Hiroshi wants to explore during his week in Durham. While the Bulls have allowed us near-free reign at the stadium, the locker room is sacred ground, the players' protected and sanctified home.

Hiroshi has a remarkably calm presence. His build is slight, and his natural expression is friendly, unassuming and inquisitive. I can only imagine that it is this quality that helped him receive a visa to North Korea for a photo project a few years ago. The North Korean authorities even allowed him to bring his medium format Hasselblad, the same camera he is using on this day.

The Bulls are on the road this week, so access to the locker room comes easily. Walking around the space feels somehow voyeuristic. Everywhere are traces of the personal, from the jerseys hanging in lockers to the shower stations and sinks with different types of soaps and shampoos. After taking a shot of a shower, Hiroshi heads back to the

locker room to make a test print. He shows me the result: two bottles of shampoo next to a steel shower console set against a cinderblock wall. The composition is simple and austere, yet it is also delicate and achingly intimate—or am I reading too much into it? Couldn't it just be a picture of a shower and two shampoos?

A little later Hiroshi walks slowly around the locker room, carefully examining each cell and taking photos of salient personal effects along the way: a faded Polaroid of a woman, a child's drawing, a group shot of men wearing bulletproof vests and holding guns in what looks like a hunting party. Hiroshi photographs this item extensively, before discovering something even more enigmatic at the bottom of the same locker—a six-inch-high plastic figurine of medieval armor.

We walk out to the lounge, which has a weight machine, a card table, and a big-screen TV. The television part of the room is dark and littered with objects. Hiroshi quietly examines them before finally fixing on an object that was completely invisible to me before, but which blows my mind the minute I register what it is.

Scott, the Bulls' clubhouse manager, walks in, and Hiroshi innocently asks, "What is this?"

"One of the players is a big hunter," Scott explains. "That's his bow. And this deer is his target. Sometimes they take it out on the field and have target practice."

Perhaps I am imagining things, but under Hiroshi's calm veneer, I detect an ever-so-faint note of unbridled photographic relish.

These experiences with Kate and Hiroshi stick out in my memory as microcosms of the entire season. Every shoot had the feeling of a mythic journey to enlightenment, a puzzle to slowly solve, a story to let unfold. Over the course of the season, what started out as a vacant field with no particular resonance developed into an intricate tapestry, rich with associations and meanings.

Each photographer approached the project in a markedly different way, yet each made her or his own discoveries, and each led me to new ways of seeing the same phenomenon, a Triple-A professional baseball game, in all its infinite and diverse parts. Although the season has ended, the experience has not. My video footage and photographs provide new revelations every time I look at them.

Which brings me to my final point. What I describe above is not exactly the truth. It is wishful thinking; an idealized version of what I would like to *believe* I thought and perceived at the time. What was I actually thinking then? *Is my lens in focus? Did I remember to press the shutter?*

It is all just an instinctual, pell-mell rush to get the shot. The rest comes later.

ARTIST STATEMENTS